KU-006-022

HELLO
my name is

CRAP
GRAFFITI

3 5 7 9 10 8 6 4 2

First published in 2012 by Ebury Press, an imprint of Ebury Publishing

A Random House Group company

The Random House Group Limited Reg. No. 954009

Addresses for companies within the Random House Group can be found at **www.randomhouse.co.uk**

A CIP catalogue record for this book is available from the British Library

The Random House Group Limited supports The Forest Stewardship Council® (FSC®), the leading international forest certification organisation.

Our books carrying the FSC label are printed on FSC® certified paper. FSC is the only forest certification scheme endorsed by the leading environmental organisations, including Greenpeace. Our paper procurement policy can be found at **www.randomhouse.co.uk/environment**

Nothing in the book reflects the views of the authors or publishers.

ISBN 9780091948627

Design and typesetting: Adam Elliott

Printed and bound in Italy by Graphicom srl

To buy books by your favourite authors and register for offers visit **www.randomhouse.co.uk**

FOREWORD

Graffiti can be a diverse form of expression and thought-provoking art; whether painted on the side of a train or on a canvas hanging in a gallery. Or, as you will experience in the pages to come, it can be crude drunken daubing, nonsensical statements or hilarious outpourings of uncontained rage.

Crap Graffiti documents these bizarre and puerile creations, celebrates the inept and enthusiastically applauds creative dyslexia. This is definitely not art, but really awful, lame graffiti: the incompetent attempts of beginners and the 'profound' musings of lunatics scrawled on the back of toilet cubicle doors.

One of our earliest and most inspiring finds was on the fence outside our workplace. Someone had spray painted the legend 'Girls Legs Are Food'. On a truck next to that, it said 'Every Girl in Eastbourne I am going to eat their legs'. What had motivated this person to buy some paint, go to the back end of an industrial estate in Eastbourne in the dead of night (this location was not somewhere you would ever just stumble across) and write this on a fence? Could their secret obsession with eating girls' legs only be expressed in this way? What was the mysterious story behind the Eastbourne leg cannibal?

We've now received pictures of these tiny acts of resistance and insanity from around the world. Is there a strange, profound truth to be found amongst them? What kind of person scales a building just to write a single swearword on a wall? What sort of twisted genius looks at a poster and realises that a small modification will subvert the entire meaning? And why would someone with both a marker pen and a public canvas on which to write poetry or share their innermost thoughts, instead opt to draw a picture of a cock? We present these photos with no judgement on their content or 'artist', but just simply ask you to look at them and ponder 'why?'

Adam Elliott and Richard Frazer
crapgraffiti.com

Please keep off seats

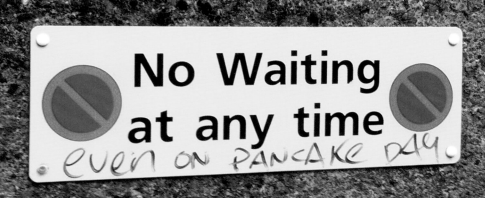

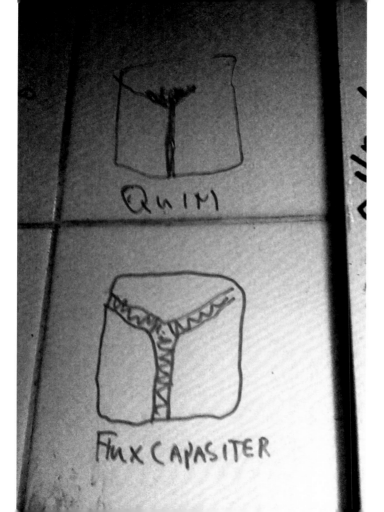

Quim

Flux Capasiter

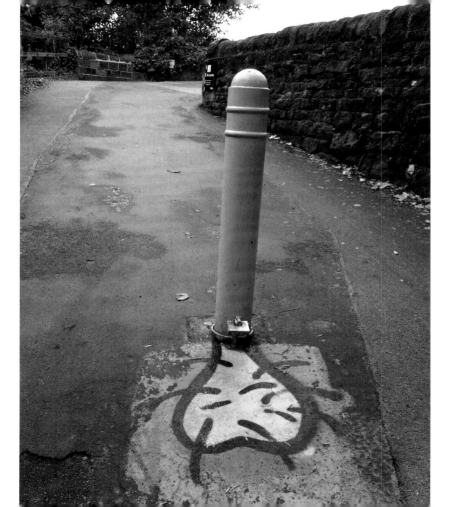

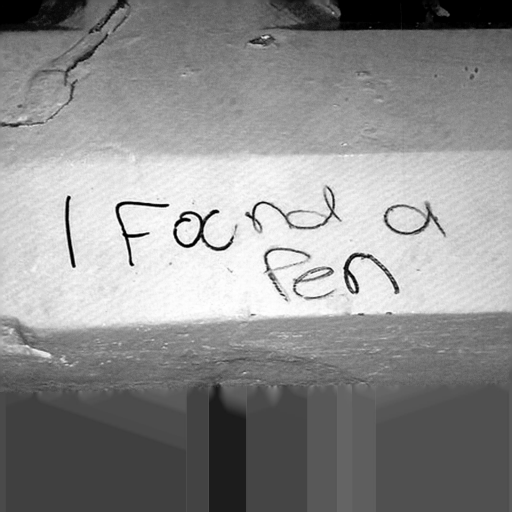

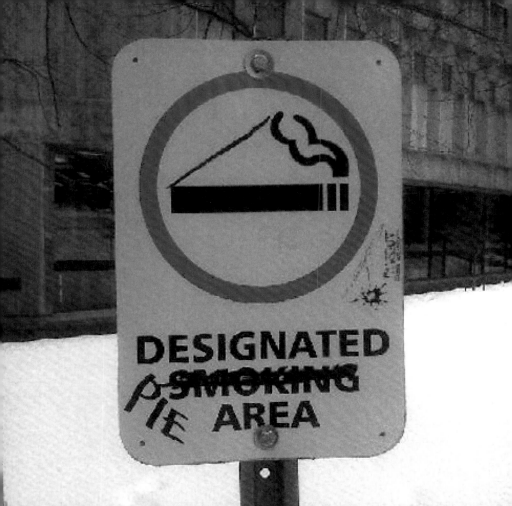

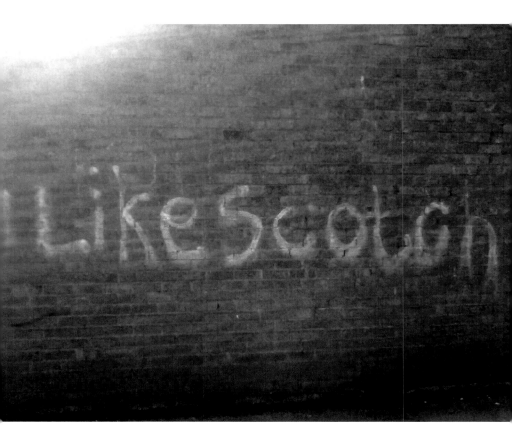

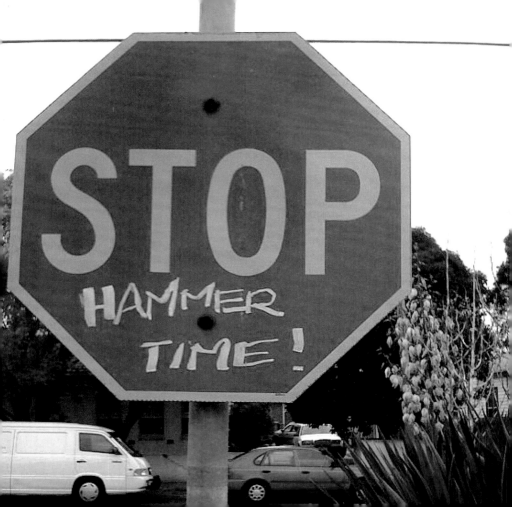

BASILDON DISTRICT COUNCIL

BROWN ASS
ONLY

CONTINENTAL 1100

SUPPORT SOUTH WALES POLICE IN THEIR ANTI - GRAFITTI CRACKDOWN!! TOGETHER WE CAN BEAT IT!!!

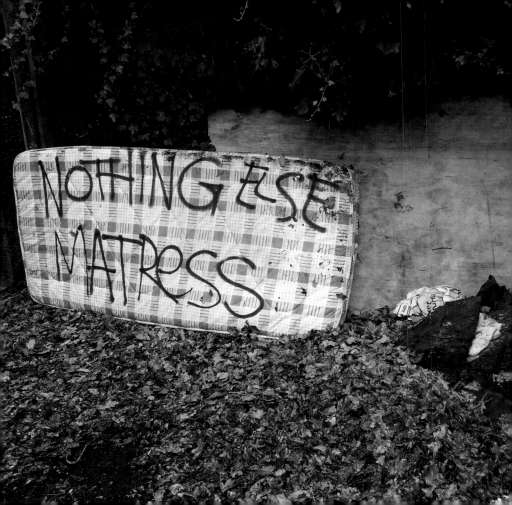

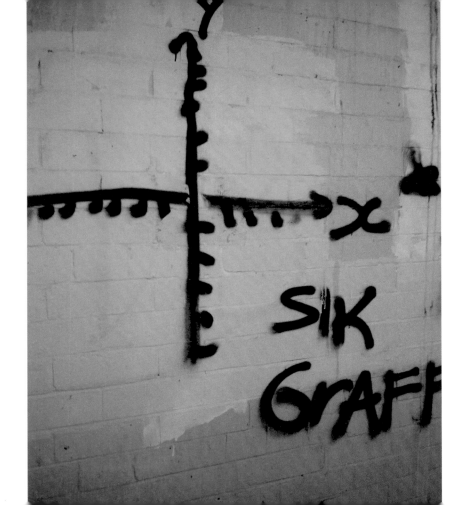

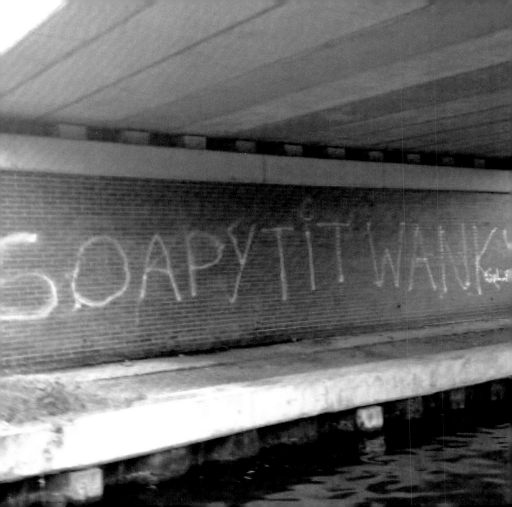

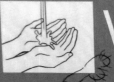

Wet

Soap

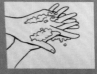

Wash

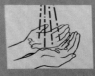

Rinse

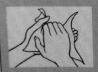

Dry

Stop germs spreading.
The power is in your hands.

Have you washed your germs away? Wash your hands.

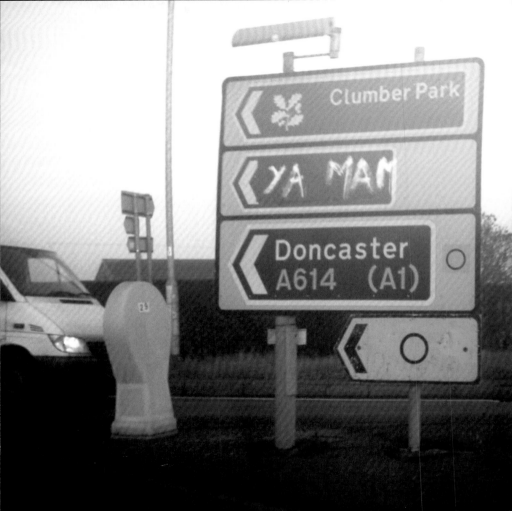

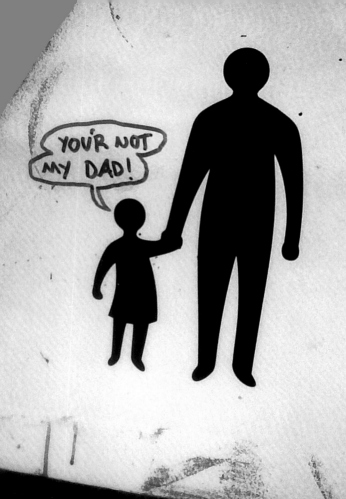

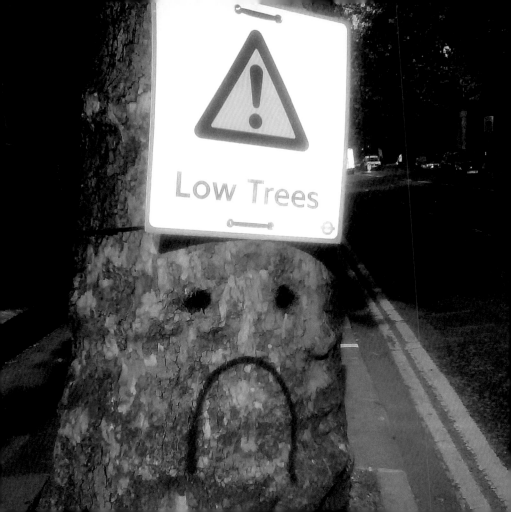

Get around with
a little hand Job
from me

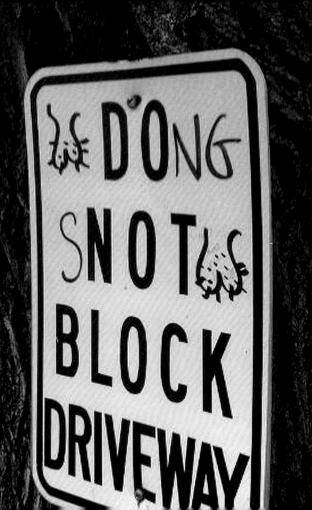

Anyone can pee on the floor,
Be a HERO...
Shit on the celing!

 - DAN
OHIO 2008

be a real hero
spell check

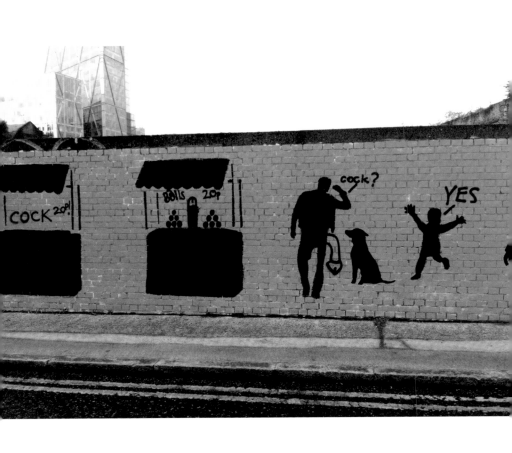

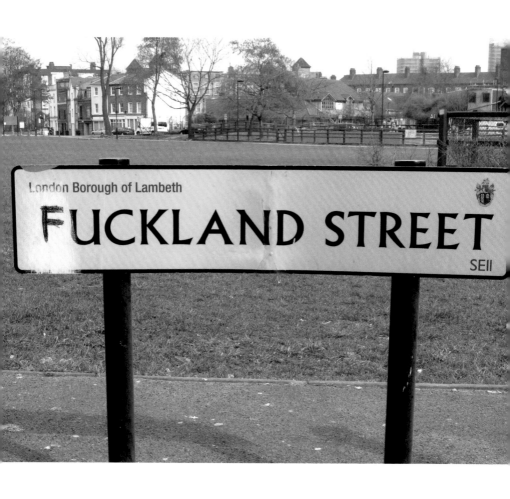

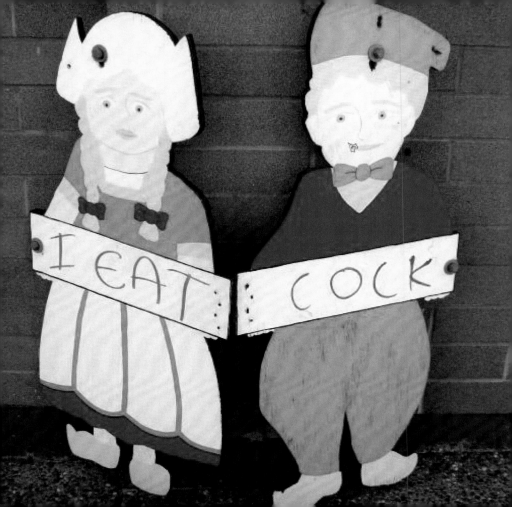

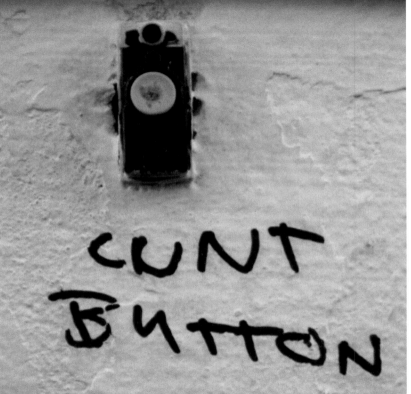

"**THERE IS MORE TO LIFE THAN INCREASING ITS SPEED**" *THAT'S WHY I TAKE THE DISTRICT LI*

— Mahatma Gandhi

Heard a quote? Get in touch at tfl.gov.uk/art

MAYOR OF LONDON Transport for London UNDERGROUND

FRED DIBNAH
DONE.
9/11

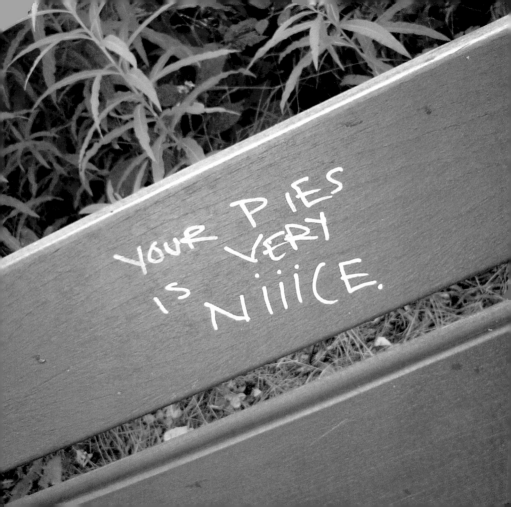

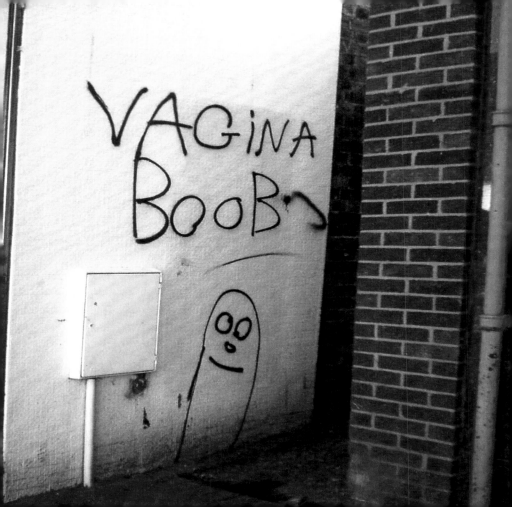

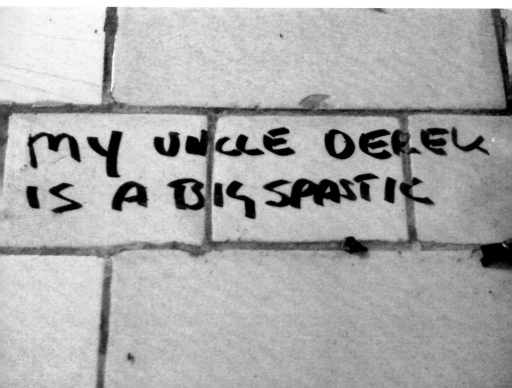

PAC JARAD

PLANNING PERMIT SUBMITTED

§ GLORY HOLE FOR JARHEAD

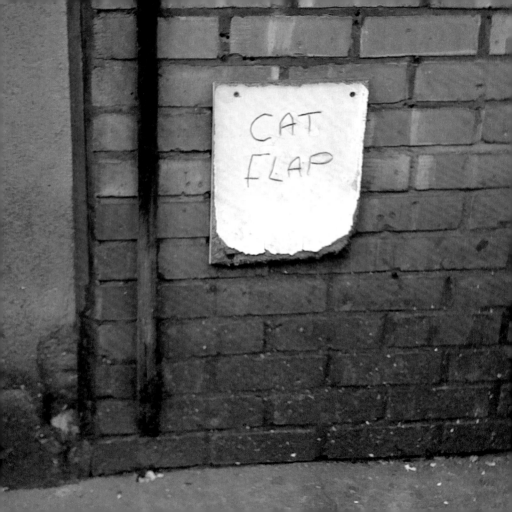

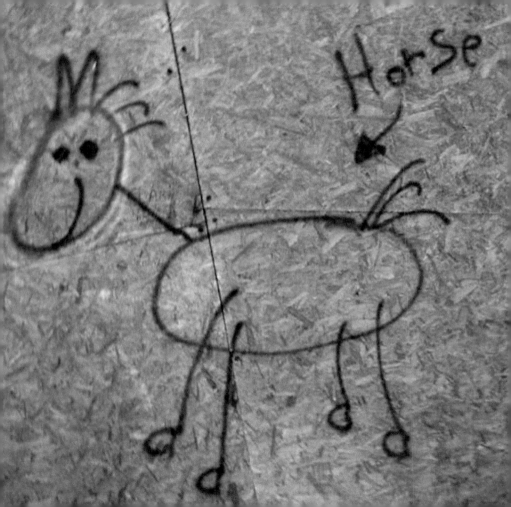

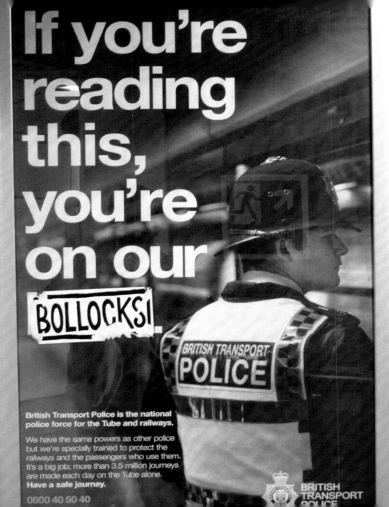

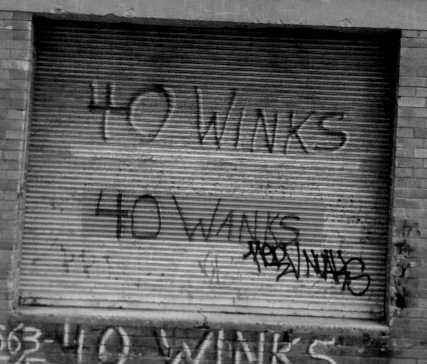

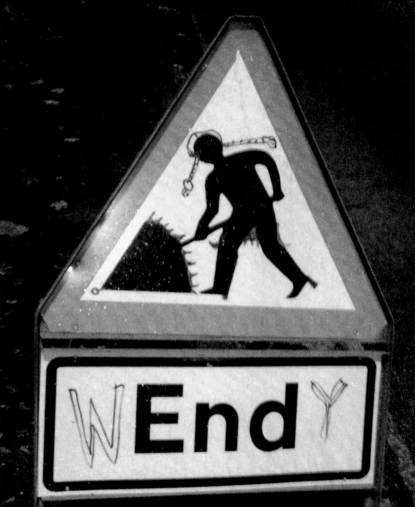

I'M
SPARTACUS

YOU'RE
A
CUNT

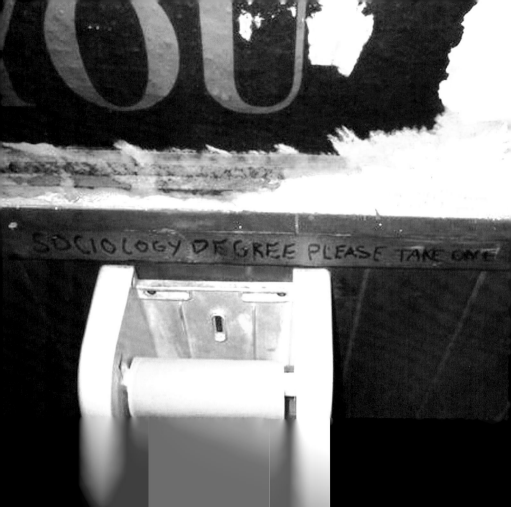

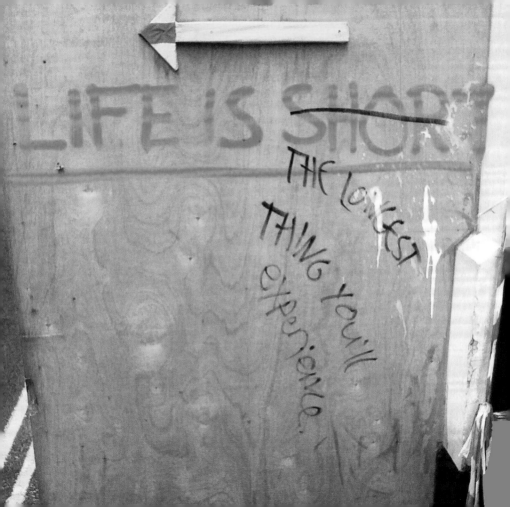

VISIT
EXMOUTH MARKETS
NEW MIDDLE
EASTERN
CHEESE SHOP

"CHEESES OF
 NAZARETH"

THE **Recycling** **Partnershi**

CARDBOARD ONLY

BANANAS ARE WELL SHIT!

HEALTH & SAFETY
MANAGMENT

OHSAS 18001 : 1999

ENVIRONMENTAL
MANAGMENT

ISO 14001

QUALITY
MANAGMENT

ISO 9001 : 2000

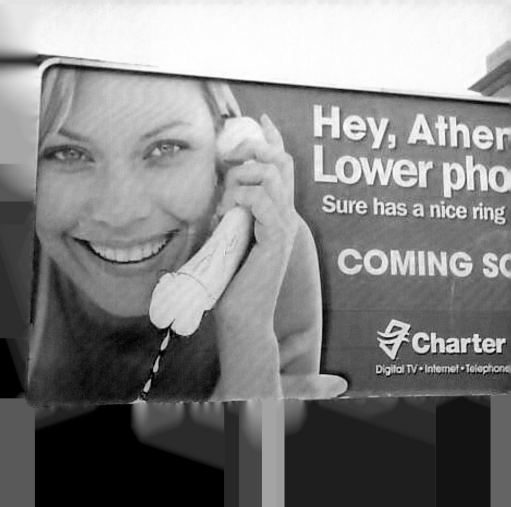

MY NUMBER TWO FAN

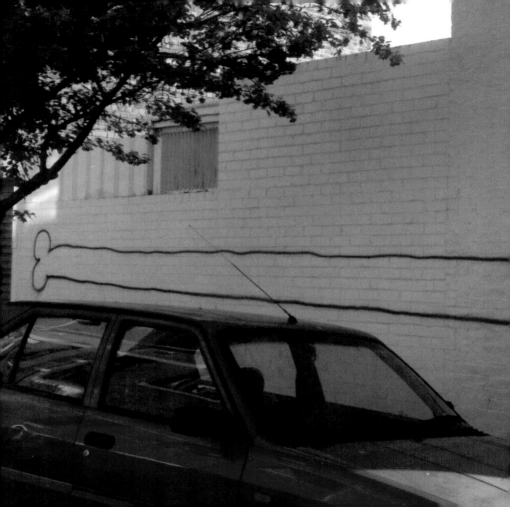

TOY STORY 2 WAS ALRIGHT

cos my mum

u were

MINGE ST 5

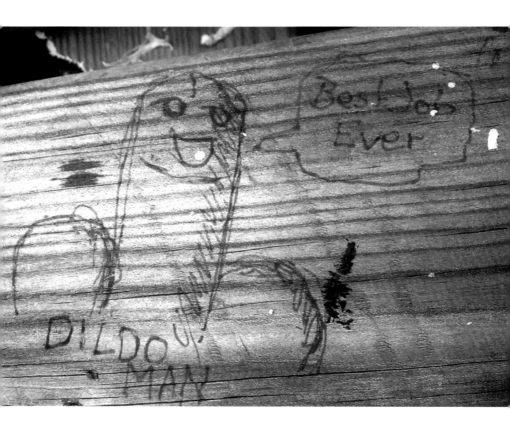

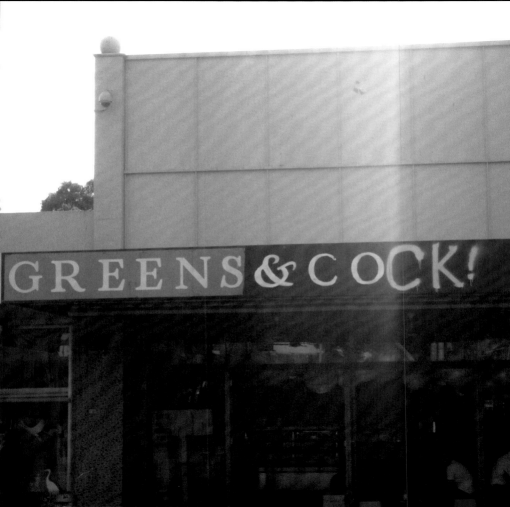

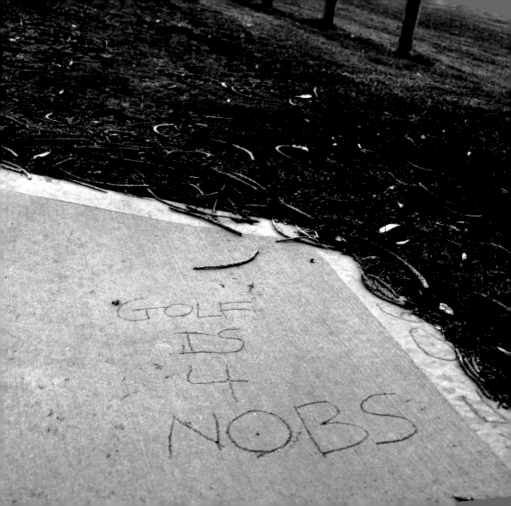

CHeeSe
is a
TyPe of
MeaT !!!

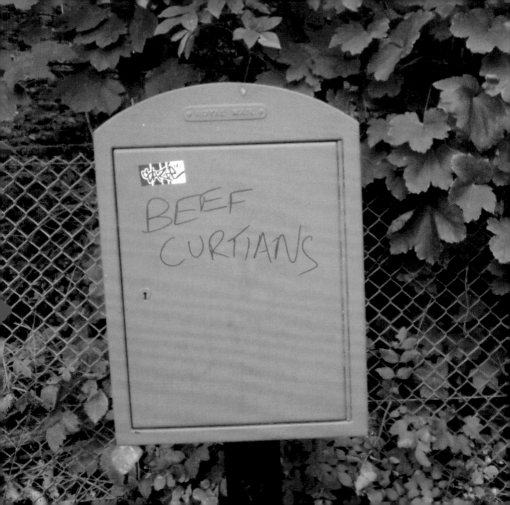

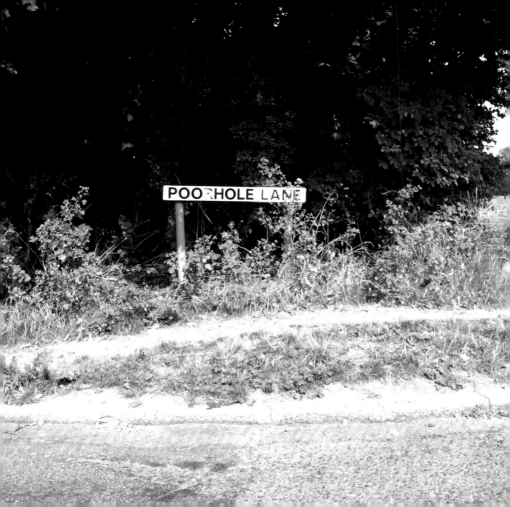

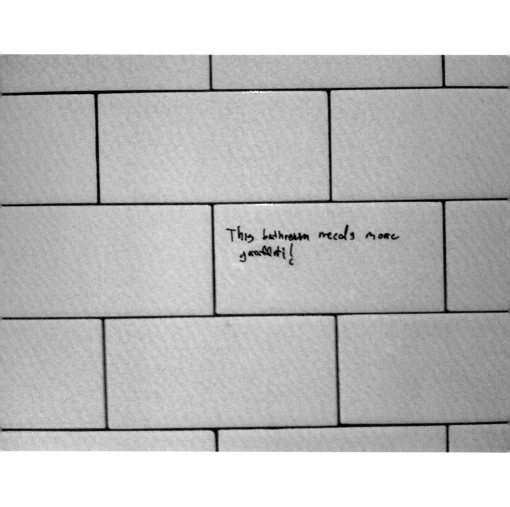

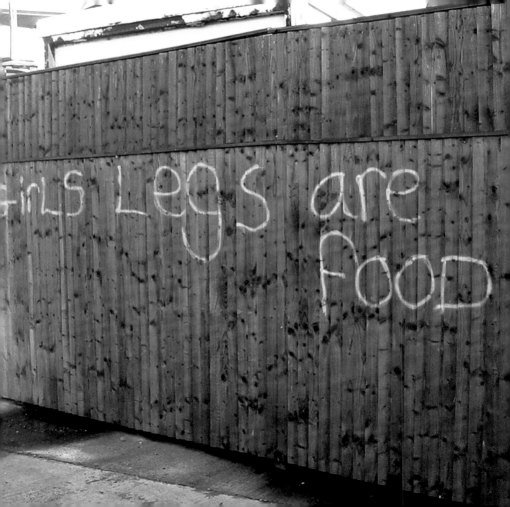

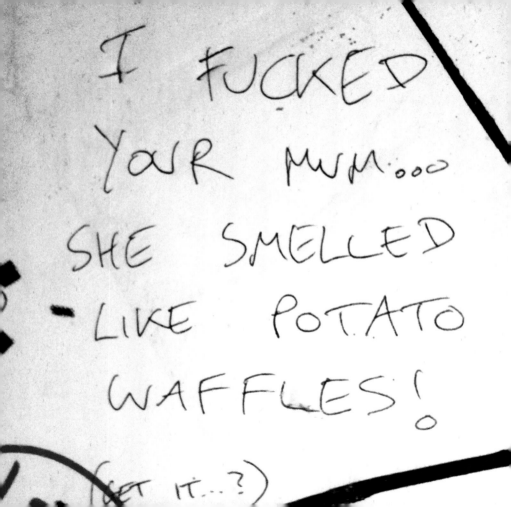

I HAVE WASTED SO MANY YEARS...

ON TECHNOLOGY

Lemonade
in beer?
fuck off
Nob head.

DC is a cunt

↑ Alternating Current is Much better

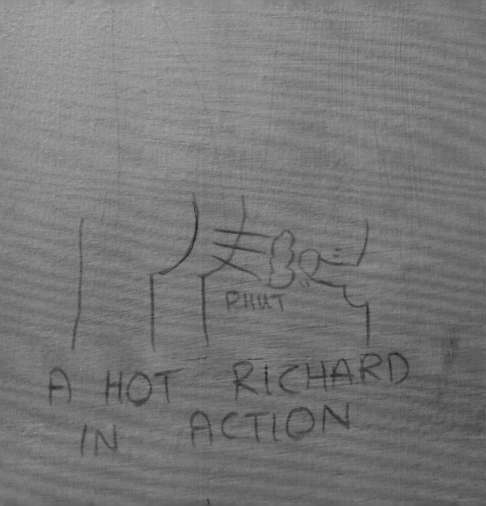

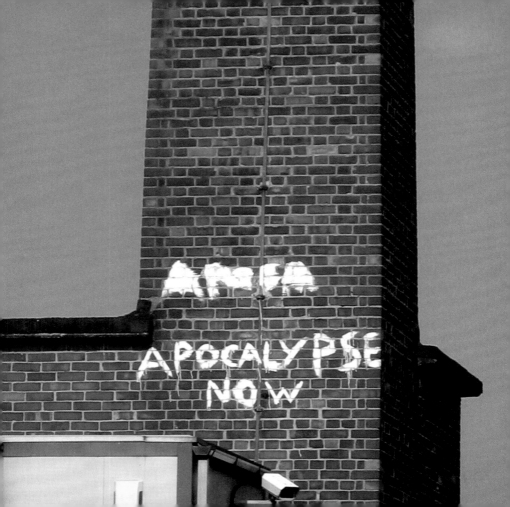

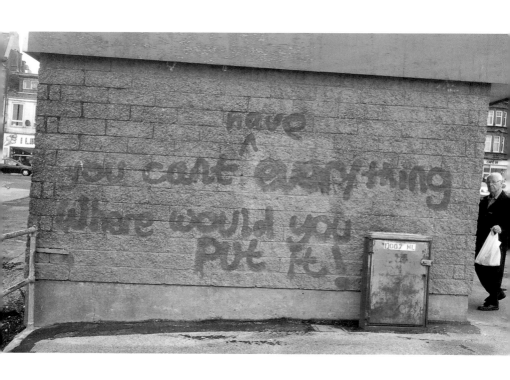

A1

The NORTH

Finchley 2

(M1) 5

×

+

Brent Cross 5

=

Watford 15

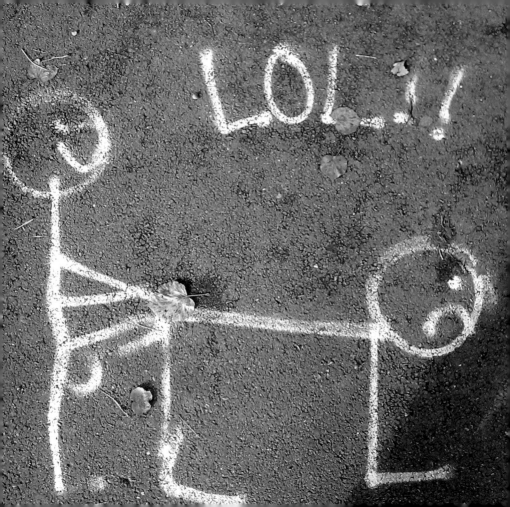

Please leave these toilets in the condition you would like to find them.

I WOULD BUT I Don't have any coke or hookers??!

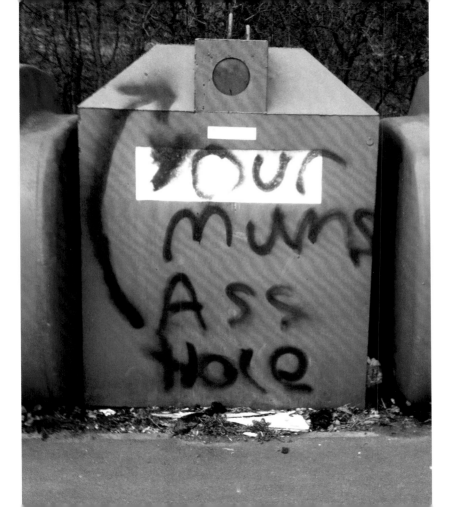

If -you can
read this...

you're a
lebsinon

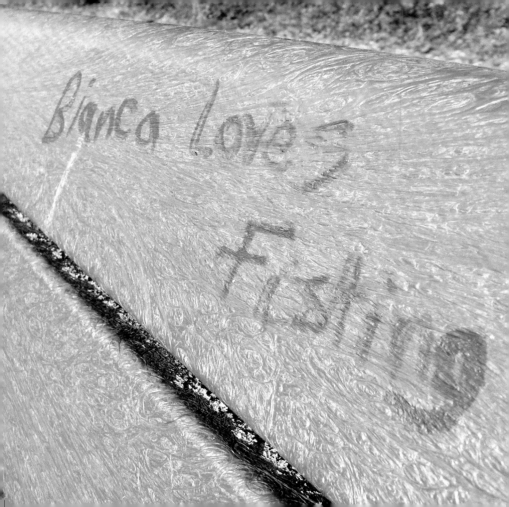

You could,
and probably wil
Win A Rabbitt

have girls
like it up
the norwich
airport

how to cut cling-film

= your op

1. get cling-film
2. get scissors
3. cut cling-film

scissors

(most norwich city fans like to use this method)

Don't
Bro
My

www.
Robot
The

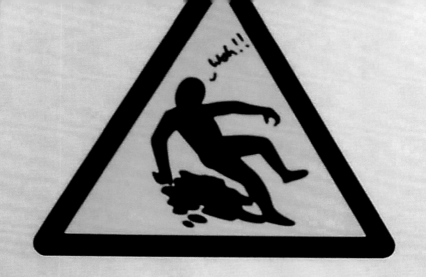

CAUTION

~~Slippery Surface~~
Rocket Shoes!!
LoL.

the poo scale

1 2 3 4 5 6 7 8

ẙck
it wont
stop coming
out!
(butt
plug?)

Perfection.
like a slippery
seal sliding
off a rock.

Fuck it
wont
come
out
(eat sum
fruit)

avoid
poppers

love
peat
it

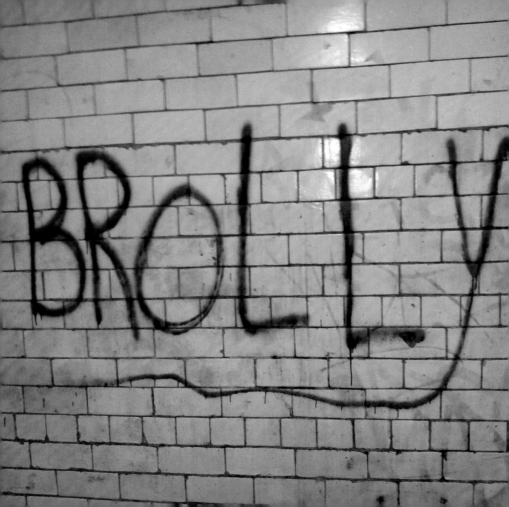

oee happy

WHY?

Because it's better than being a miserable prick!

IT'S NOT THIS EASY TO TELL WHO'S GOT

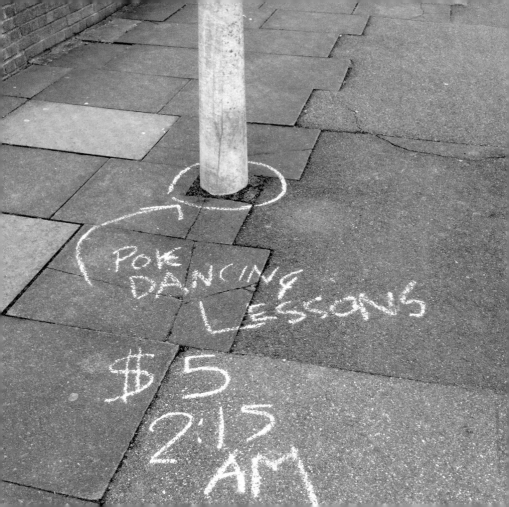

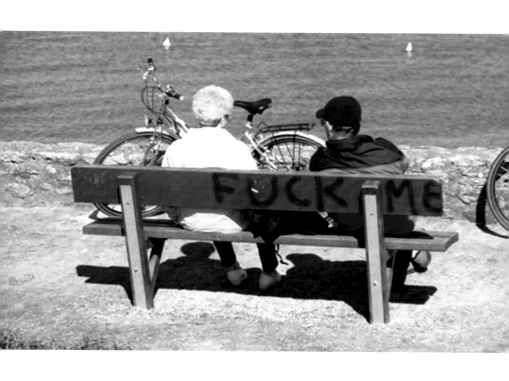

97

I wont my BMX
Back

FRONT OF GARAGE DOOR

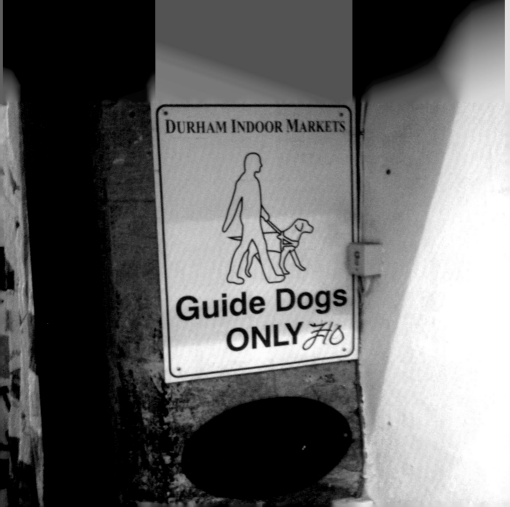

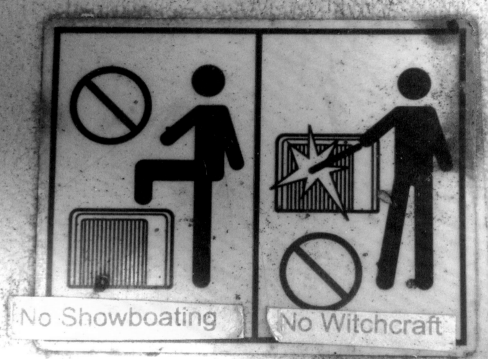

No Showboating

No Witchcraft

I JUST WROTE ON
THIS WITH PEN.....
COZ I THINK I'M
COOL.

PS take that
Society! And So

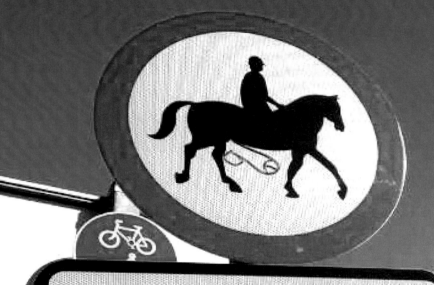

No Horse Buming **Riding**

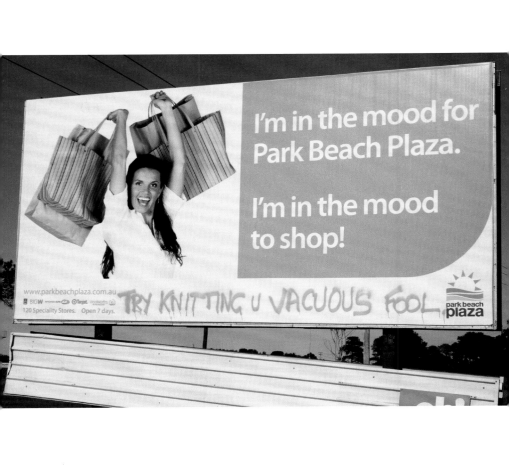

YOU CLEANED MY GRAFFITI AND THIS HURT MY FEELINGS

NO SMOKING
IN DICK AREA

PLEASE LET ME OUT. IV BEEN
TRAPPED IN HERE SINCE WENDSDAY
TEATIME, 1997. I NEED TO
WATER MY PLANTS

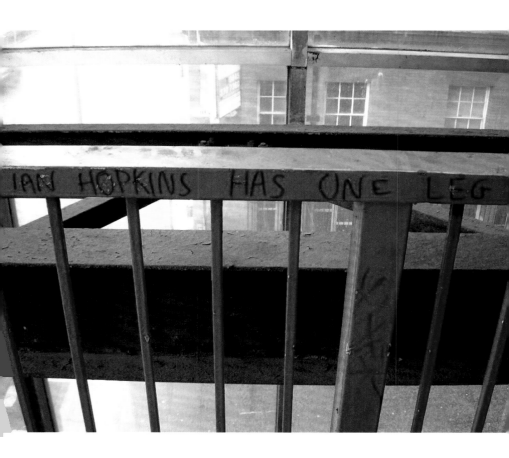

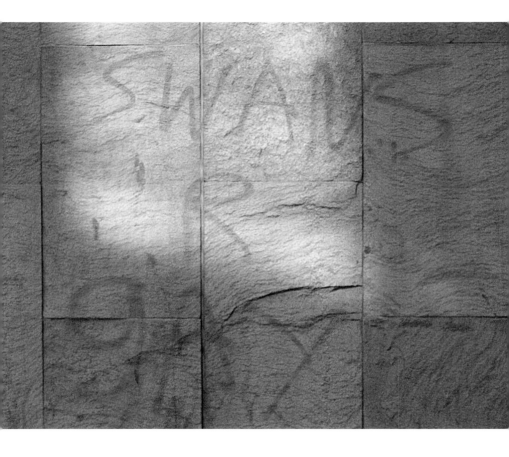

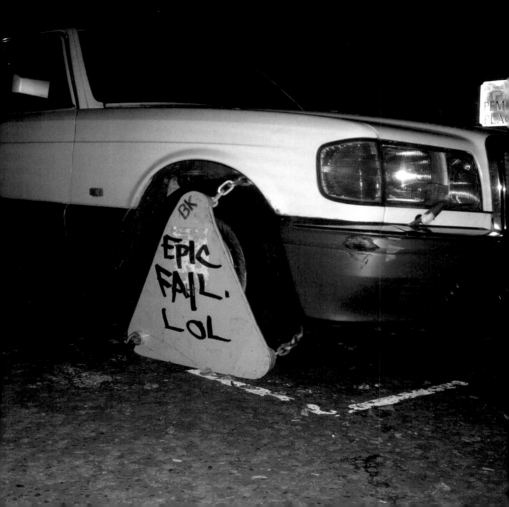

CHEESE BURGERS
will be the
DEATH of you!

Human burgers will
be the death of me.

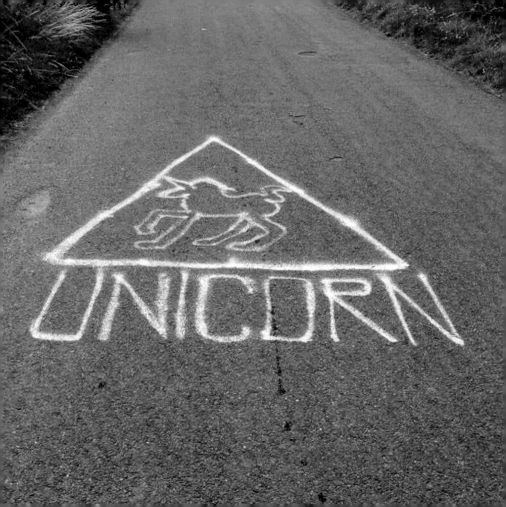

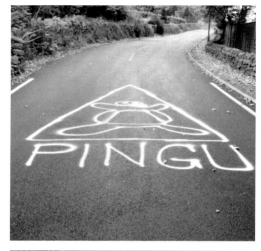

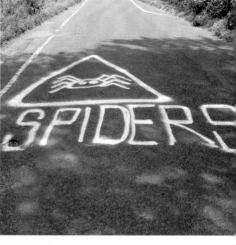

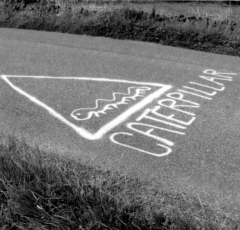

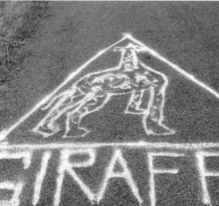

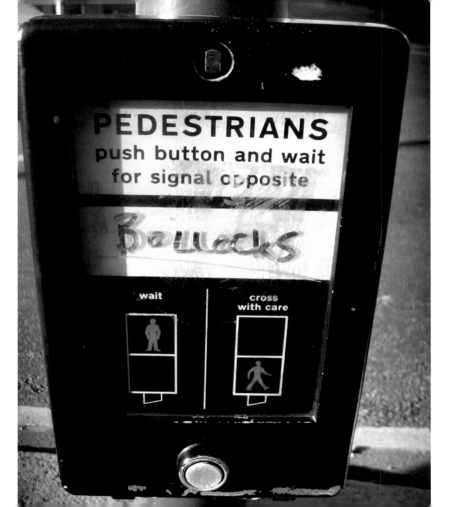

YOUR MOTHER IS THAT SMART
I WOULD SAW MY OWN FEET OFF
WITH A RUSTY BOW SAW AND WALK
OWA TWO FIELDS OF SALT 'N' VINEGAR
CRISPS JUST TO SNIFF THE EXHAUST
FUMES OF THE VAN TAKING HER
DIRTY KNICKERS TO THE LAUNDRETTE
FACT!

PUSH BUTTON

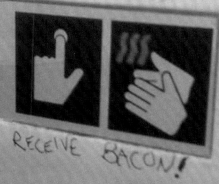

RECEIVE BACON!

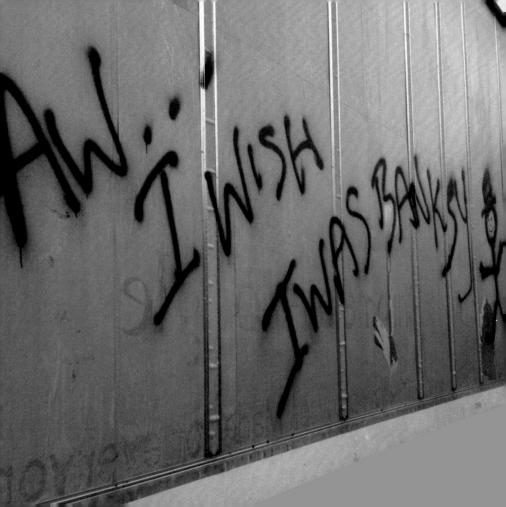

I Don't Normally Shit
While away from home...
But when I do...

I prefer the Handicapped Stall.

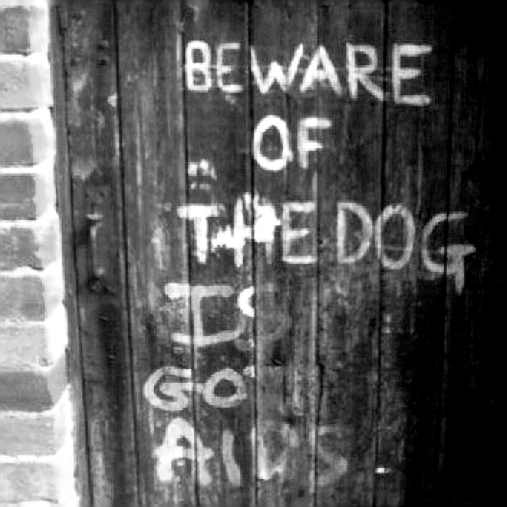

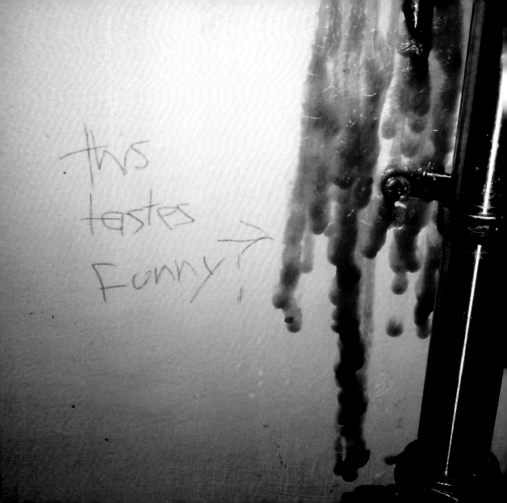

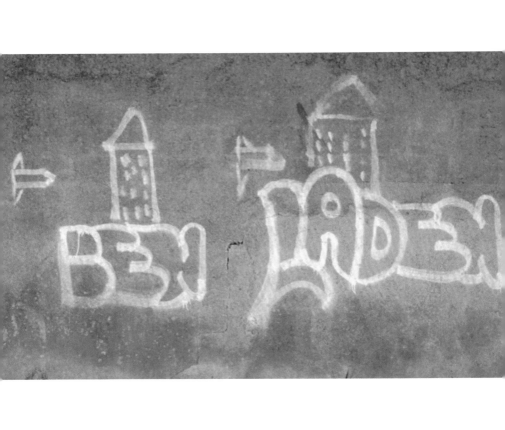

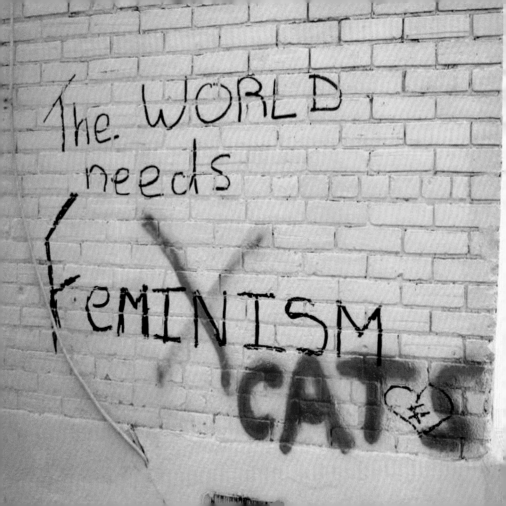

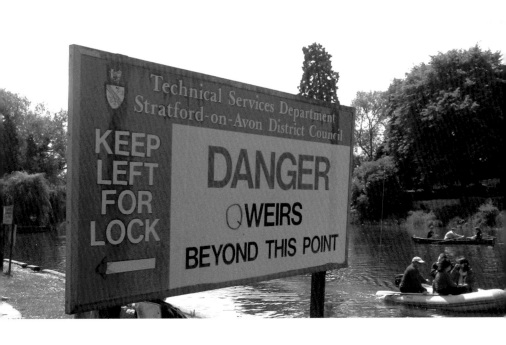

Technical Services Department
Stratford-on-Avon District Council

KEEP
LEFT
FOR
LOCK

DANGER

WEIRS

BEYOND THIS POINT

football is shit

i am art
what are you ?

YOU'RE A DICK,

WHAT AM I ?

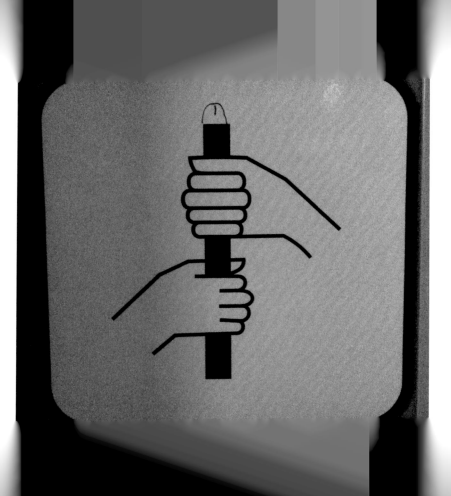

Robert Scott

CAUTION

WET
FLOOR

"Thats what she said!"

Phil
Rims
goats!

WWW.
CRAPGRAFFITI
.COM

LONDON, MILAN, PARIS... PUTNEY?

We are lucky enough to receive submissions from all over the globe and our site would be nothing without our army of crap graffiti spotters. Join them by keeping your eyes peeled for the finest crap, snapping a photo and sending it to us via **www.crapgraffiti.com/submissions** to see your name on our site.

Also bookmark us and keep your eyes out for monthly competitions!!

THANKS

Adam Elliott would like to thank: My Mum, Carol, for painting the Miss Piggy on the wall. My darling wife, Zoe Elliott, for always being lovely. Rudy 'Danger' Elliott & Eden Elliott for laughing at 'naughty' words. 'Matty Boy' Mead for being a kick ass listener. Zeren 'Mr Bitten and Written' Wilson for saying 'You're the Bomb Baby!'. Leigh Parry at InHouse Design for teaching me the ways 'Hai Sensei'. Mrs "H", Mimi and the Cake Mechanic (Jude, Esme and Robin). And last but not least **YOU** for submitting.

Richard Frazer would like to thank: P RIzza, Lord Satan, Crazy Mum, The Eastbourne Leg Canibal, The Polegate Init Crew (you came so close to being more famous than you should be), Grafik Warfare, B3ta.

CrapGraffiti would like to thank:

Adam Meiklejohn

Aled Morris

Alex Young
www.brainofalexyoung.com

Amy

Andy

Aziza Azul
www.azizaazul.com

Barrie Weston

Ben Campbell

Ben Habbershaw
benhabs.tumblr.com

Benito Branco

Billios Serios of Yorkshire

@bobpullen
(with thanks to Kevin Foxton)

Charlie Brennan

Chef Chaz French
www.chazfrench.com

Chris Henry
www.damnhardwriting.com

Chopper

Cris West

Colin Lacey

Danielle Williams

Danny Francis

David Jordan Hawkins

Daz Reject

Dozy Dan

Dr John C Bullas
www.lookandbehold.net

Dylan Pugh

Ed Aves

Emil Sarlija

Geoff Leopard
www.tourist-mag.com

Greg Foat
www.thegregfoatgroup.com

Hilary Mason

Hugh Munro
dunnyart.wordpress.com

Iain Lane

Ian Rice

James

James Chant

James Ollis

Joanna Long

John-Paul Sykes
johnpaulsykes.wordpress.com

John of Taunton

Kieran Gee-Finch
www.wunderk.com

Laura Clark

Lee Richardson Foster

Libby Miller

Lindsay Smith

Liz Marvin and Andrew
Goodfellow at Ebury Press

Marilou

Mark Ashton

Mark Horse

Martin Omond
www.facebook.com/
codamusicuk

Matt Benney
www.matthewbenney.co.uk

Matt C

Maz Marriott

Michael Crompton

Miguel Martinez

Mike & Beck

Mike "Eggs Good" Wilson

Mike McHugh
www.creativesweettv.com

Naomi Mc
www.vaginadentatablog.net

Neil Delete

Oliver Roberts

Poppy Alexander

Queen Amy Vyctorya
of Brixtonia

Rob Lurted

Robert D. Schofield

Robert Newsome

Ruf Dug
www.rufkutz.net

Sam Barton

Simon Stokes
www.sstokes.co.uk

Ste Edge

Steve Mappley

Stu Bryan

The Editor at the
Matlock Mercury

"The Dragon"

The Human Fly

The Pitbull Press

Tina Ziegler
www.huntandgatherart.com

Tim Clifford

Tim McCool
www.timmccool.com

Tom
www.clowog.net

Tom Schuring

Tricity Vogue
www.tricityvogue.com

Will Blackburn

Will Hanson

William Townend